HIGHLIGHTS FROM THE BEN URI COLLECTION

VOLUME 1

HIGHLIGHTS FROM THE BEN URI COLLECTION

VOLUME 1

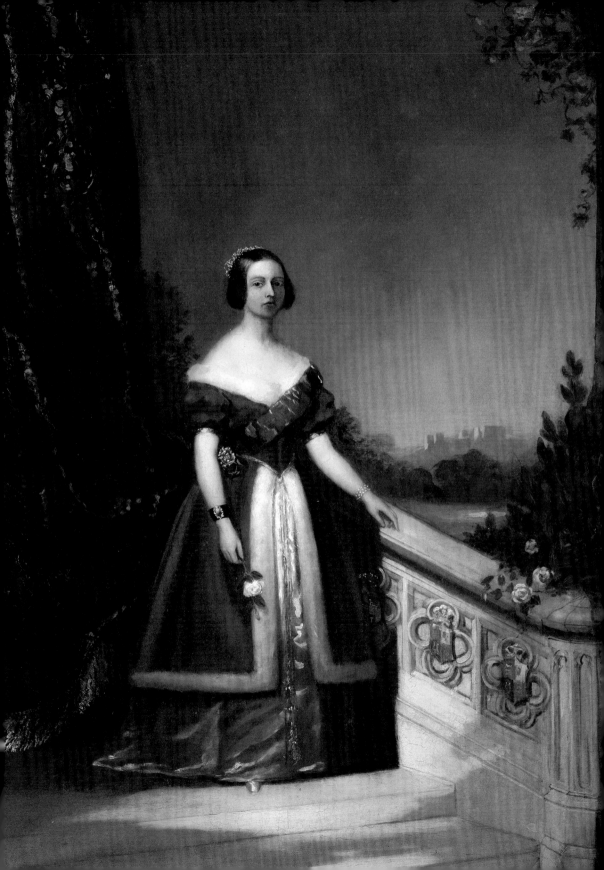

First published in 2015 by
Ben Uri
108a Boundary Road,
London NW8 0RH

www.benuri.org.uk

British Library Cataloguing-in-Publication Data
A catalogue record for this book is available
from the British Library

ISBN 978-0-900157-54-7

Edited by Rachel Dickson and
Sarah MacDougall

Designed and produced by
Isambard Thomas, London

Printed by OGM, Padova

In honour of all the
immigrant artists
who came to Britain
during the 20th century

A century of engagement with British and European Art

Ben Uri was founded by Russian-Jewish émigré artist Lazar (Eliezer) Berson in Whitechapel (according to anecdote at Gradel's restaurant) on 1 July 1915, midway through the second year of the First World War. Named after Bezalel Ben Uri, the legendary biblical craftsman who created the tabernacle in the Temple in Jerusalem, it was originally envisaged as an 'Arts Society' to provide support for Yiddish-speaking, Jewish immigrant artists and craftsmen who were forced to work outside the cultural mainstream due to discrimination and anti-Semitism.

From the start, the founding fathers' vision was a 'Jewish Art museum' in London. This extraordinary ambition for a tiny immigrant community has been realised. Their founding vision now extends to encompass immigrant communities who, together with Ben Uri, enrich London and the country as a whole, with a diversity of traditions, complimenting and adding to the unparalleled cultural mosaic of this great country.

Ambitious collecting has been at the heart of Ben Uri for its first 100 years and will continue to be so. In 1919, the Society boldly acquired a tranche of important late nineteenth century works by Pre-Raphaelite, Simeon Solomon and in the following year, David Bomberg's East End masterpiece, *Ghetto Theatre*. In 1923 £142. 10/- was raised to acquire Samuel Hirszenberg's monumental The Sabbath Rest, painted in Poland and one of the finest nineteenth-century pieces in and outside the collection, depicting a world obliterated by events of the twentieth century.

From just 80 works in 1930, the collection has now grown to more than 1,300 across a variety of media. It is a unique body of work representing a distinct academic and visual survey, and forms a significant part of British art / history and the social integration and cultural heritage of British Jewry, with a particular focus around the birth of modernism.

Analysis of the collection is fascinating and revealing and quite unique within a British and European museum context: 1310 works by 386 artists from 35 countries; 28% of the collection artists were born in the UK; another 28% were born in Germany and Poland; 35% of the collection artists are contemporary. 28% of the artists are women in contrast to national art gallery averages of 4%. 63% of the collection artists were / are immigrants. 15 different techniques are represented; subject matter as wide as any other art museum, with only 6% of the collection representing religious subjects.

THE COLLECTION

Landscapes include fine examples by Lucien Pissarro, Irma Stern, Philip Sutton RA, as well as rare, early powerful representations of city and village life by Josef Herman and Lesser Ury. Portraiture from different movements and periods includes works by Eugen Spiro, Isaac Rosenberg and Clara Klinghoffer. Celebrated self-portraits by Max Liebermann and Reuven Rubin sit alongside family scenes, ranging from the traditional by Solomon J. Solomon to the naïve by Dora Holzhandler.

Immigrant artists number total two-thirds of the collection, notably the East End-based 'Whitechapel Boys', including David Bomberg, Mark Gertler, Isaac Rosenberg, Jacob Kramer, Bernard Meninsky, 'Whitechapel Girl' Clare Winsten, and the more senior painter, Alfred Wolmark. The majority were involved with Ben Uri from its earliest years, which gives the museum a rare and remarkable social, as well as artistic, place in 20th century British and European art history.

The collection also is particularly strong in works by those who made 'forced journeys' during the years of the Nazi regime from 1933–45, including Jankel Adler, Martin Bloch, Hans Feibusch, Fred Feigl, Naum Gabo, Josef Herman, Erich Kahn, Alfred Lomnitz, husband and wife, Ludwig and Else Meidner. A number of rare early works by Israeli painters, including Moshe Castel, Reuven Rubin, Mané-Katz, Nahum Gutman and Issachar Ber Ryback, also feature.

In recent years, Ben Uri has built its collections relating to both World Wars, including recent acquisitions of works by Isaac Rosenberg and Barnett Freedman, as well as Emmanuel Levy's important *Crucifixion* in early 1942, which combines Jewish and Christian iconography in a powerful protest against the Holocaust. This acquisition provided the scholarship for another of Ben Uri's most important and celebrated recent acquisitions, Marc Chagall's gouache *Apocalypse en Lilas, Capriccio* which depicts a naked, hermaphrodite Christ to symbolize both the victims of the Holocaust and the loss of the artist's wife six months earlier in September 1944. The raw brutality of the recent gift of George Grosz's *The Lecture* (*Letter to an Anti-Semite*) and the previously acquired *Interrogation* – disturbing images of power and persecution referencing the flagellation of Christ – add harsh visual realities.

Ben Uri is exceptionally proud, too, of its most recent major acquisition, *La Soubrette* by Chaïm Soutine. This significant work, perhaps the finest example in a British museum, forms the centrepiece of the museum's growing collection of work by European masters, particularly École de Paris painters, including Chagall, Lipchitz, Sonia Delaunay, Dobrinsky, Henri Epstein, Kikoïne, Nadelman and Pascin.

Closer to home, *Mornington Crescent: Summer Morning II*, an important characteristic cityscape by Frank Auerbach, and

R.B. Kitaj's *Portrait of Sir Claus Moser*, are amongst the many important new works which have entered the collection in the last 15 years with the extraordinary support of the Art Fund, The MLA / V&A Purchase Grant Fund, The Heritage Lottery Fund (HLF), the Government 'In Lieu' scheme, enhanced by the spontaneous generosity of numerous donors and artists, to all of whom we owe a great debt of gratitude.

There are still many gaps and progressively fewer opportunities to acquire significant examples to fill them but, with your help, we will. Please enjoy this snapshot of less than 5% of this wonderful but hidden collection. This first 'Highlights of the Collection' guide is designed to give an enticing flavour of the range and volume of great art and artists in this world-class collection that, to London's loss, remains without a permanent, appropriate centrally-located building to share with so many more of the 9 million residents and 33 million visitors to our extraordinary city of London.

If you feel you can help us please be in touch direct or through www.benuri.org.uk

David J. Glasser, *Executive Chairman*

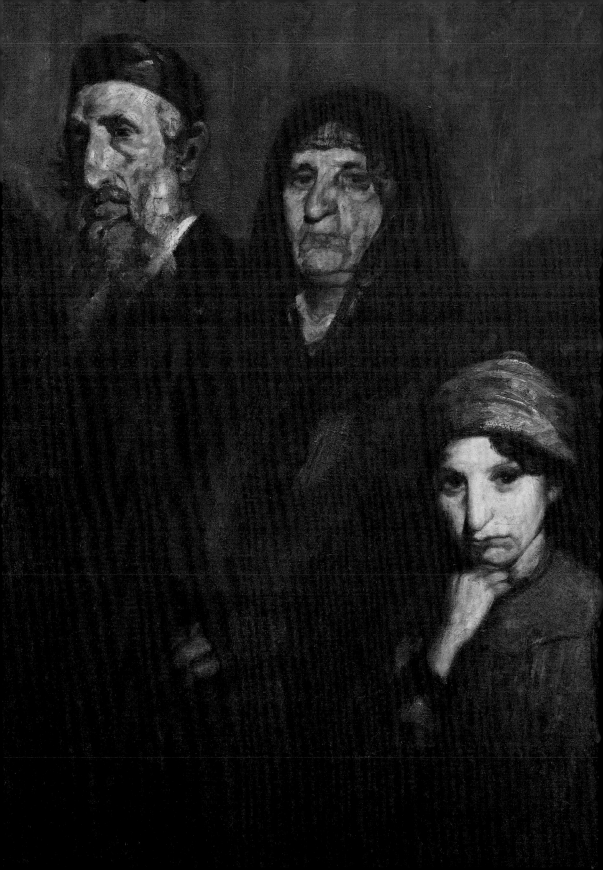

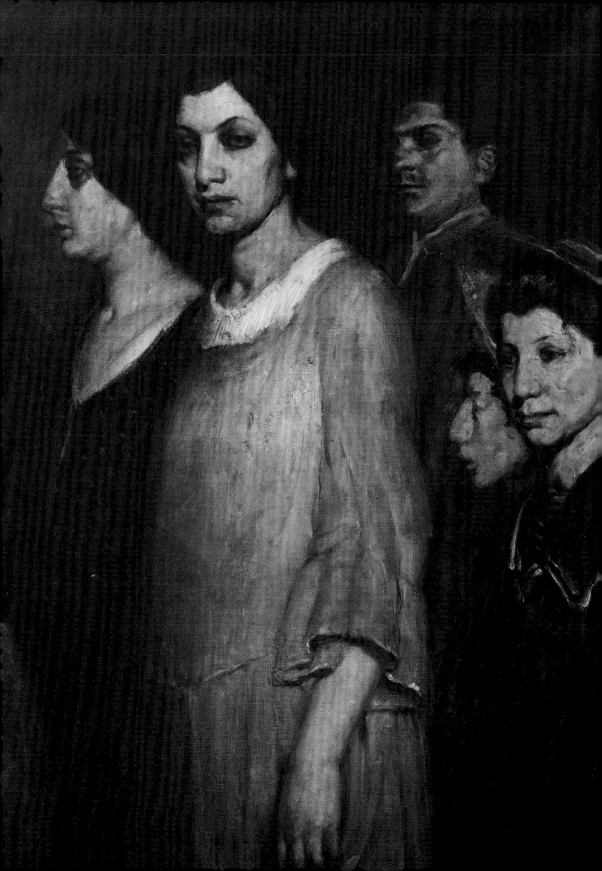

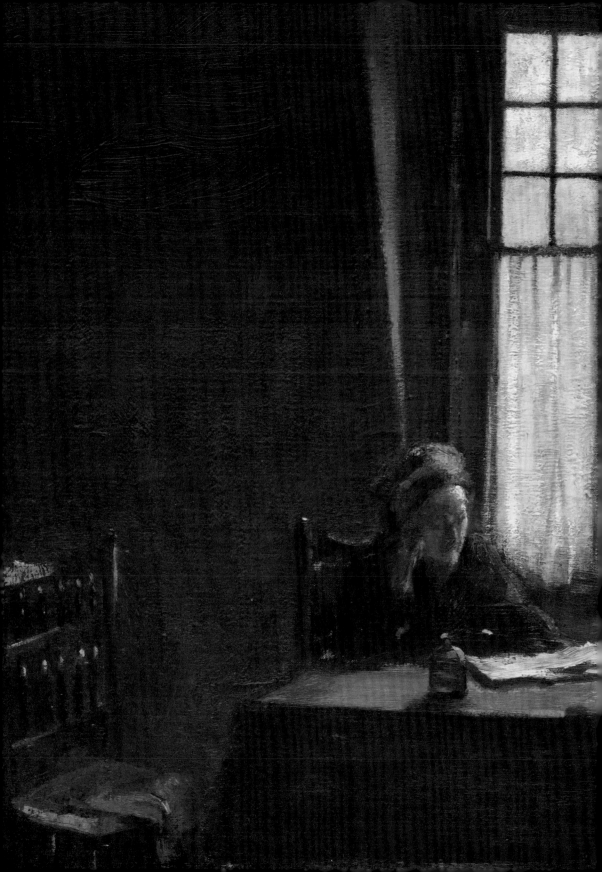

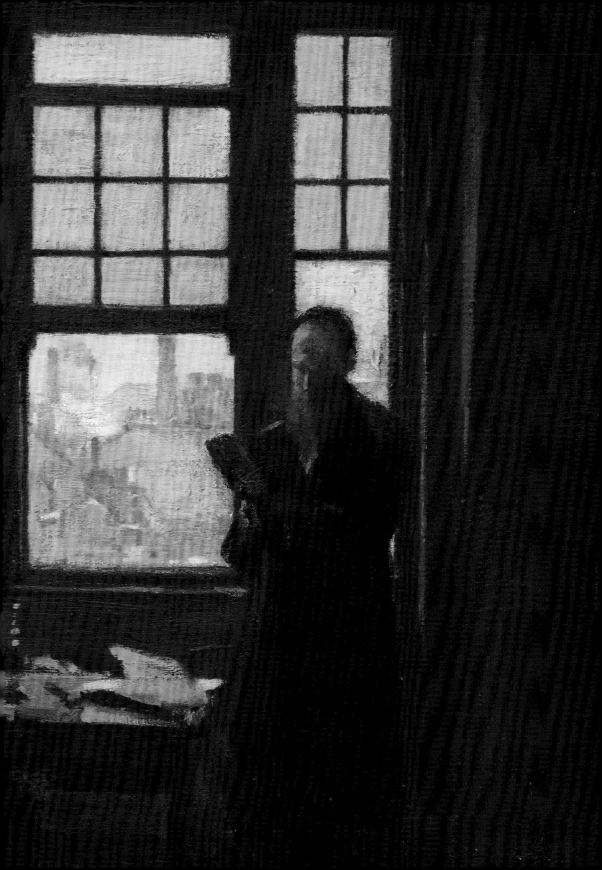

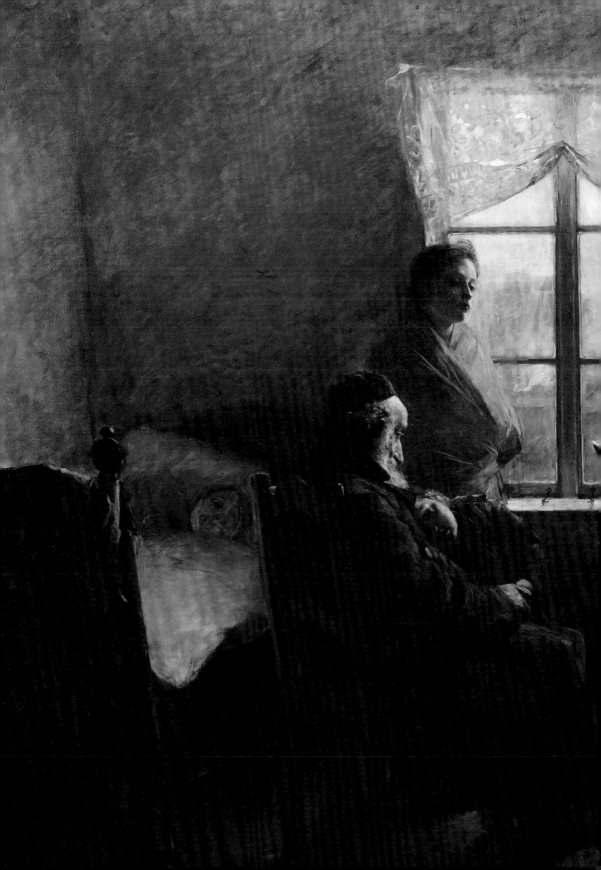

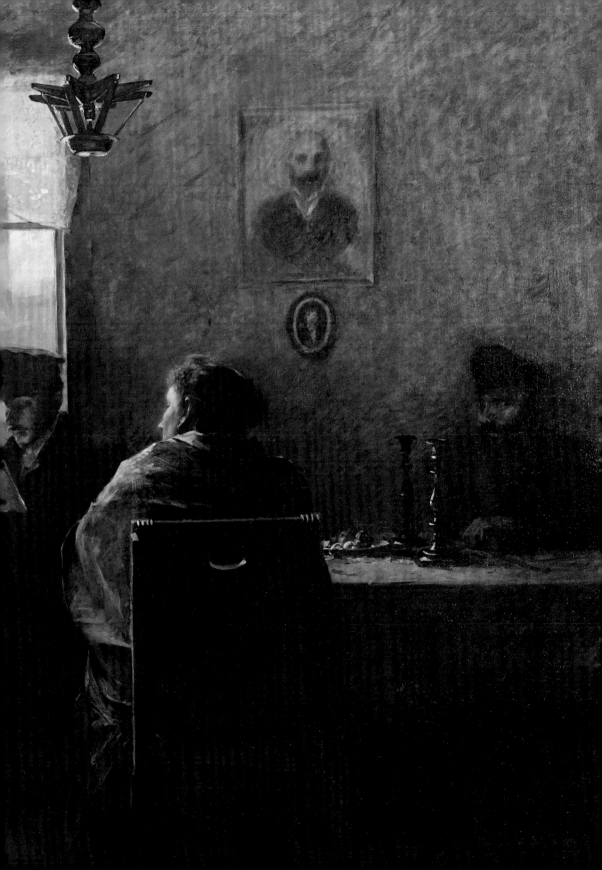

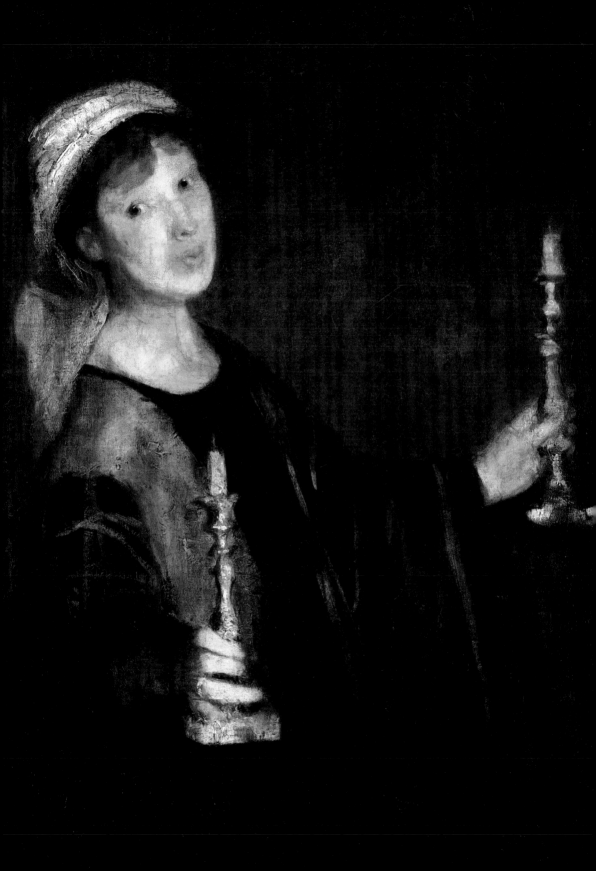

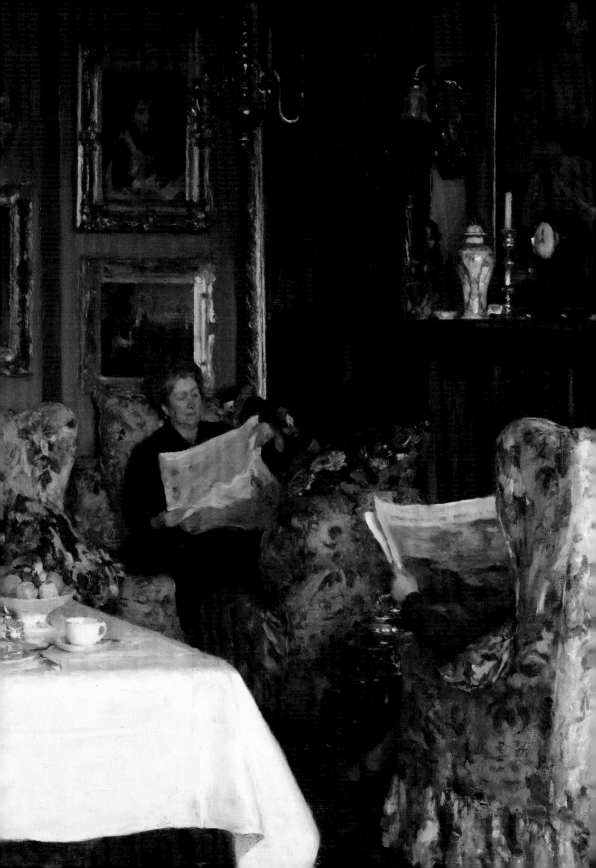

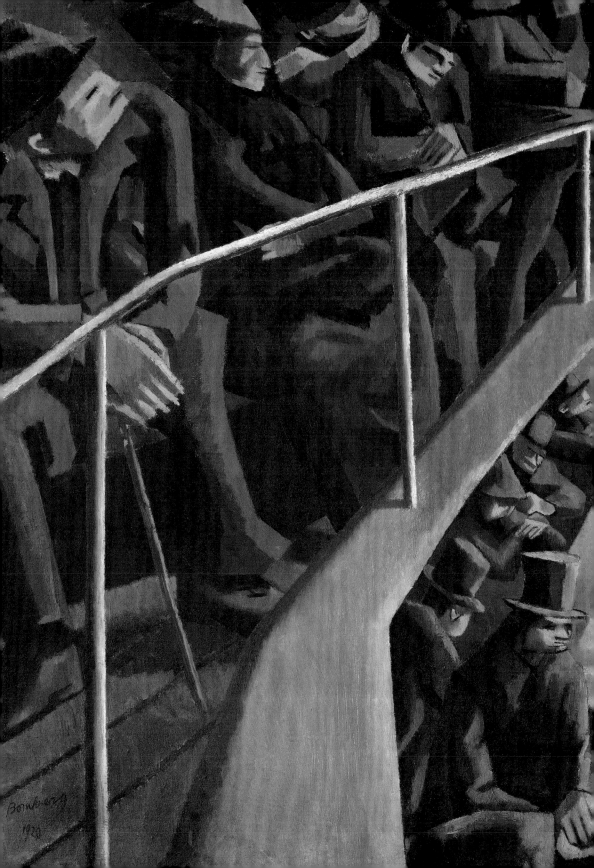

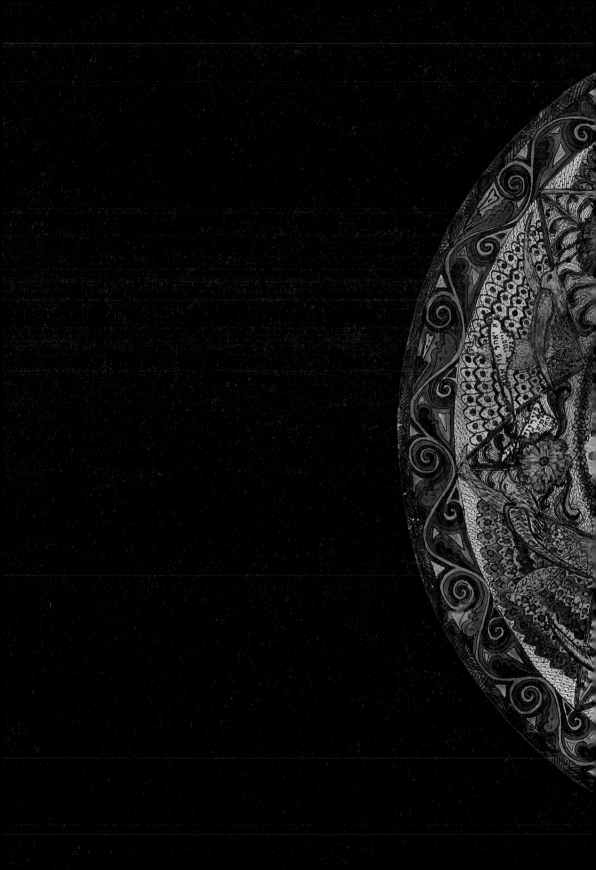

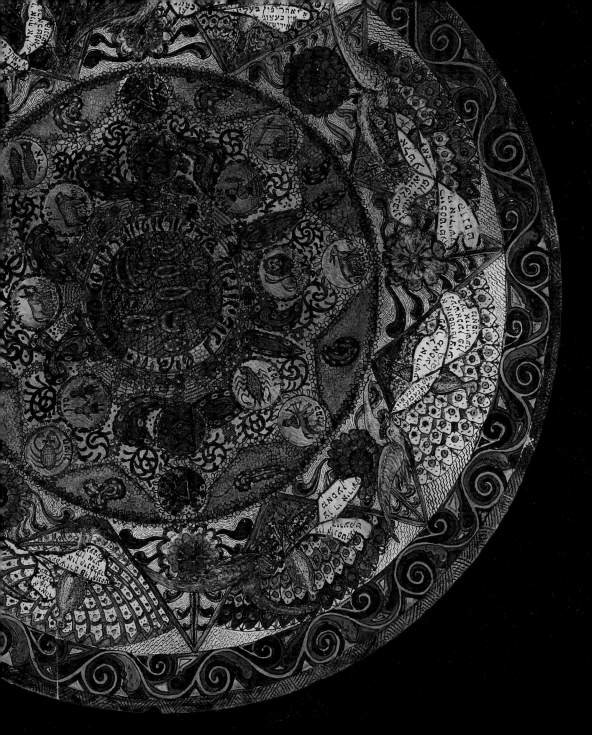

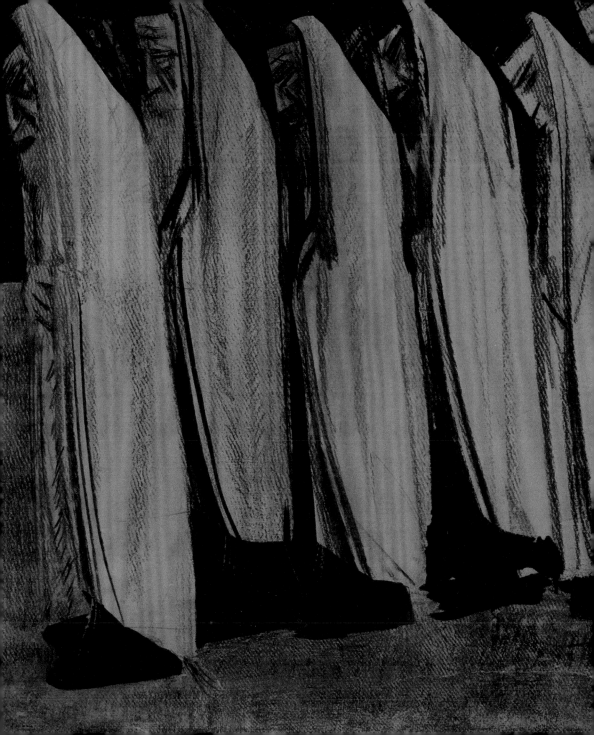

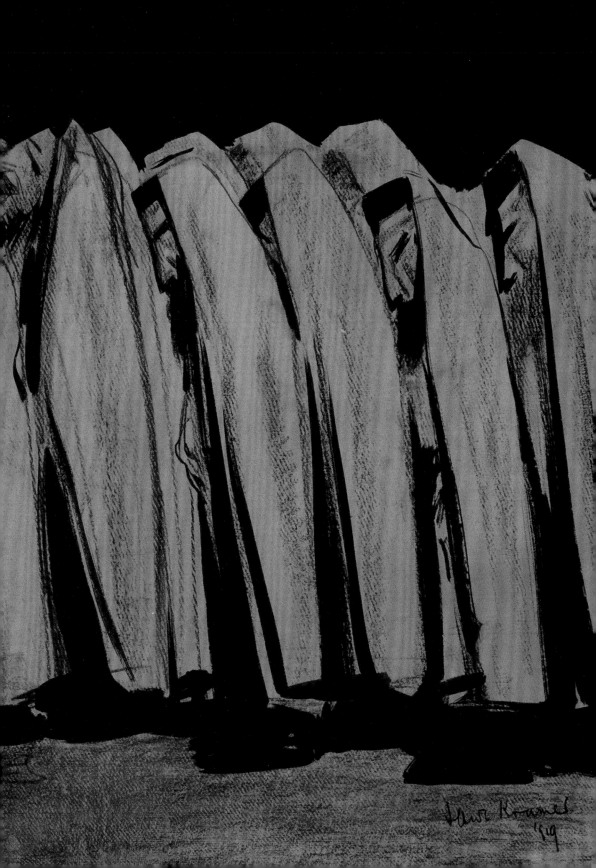

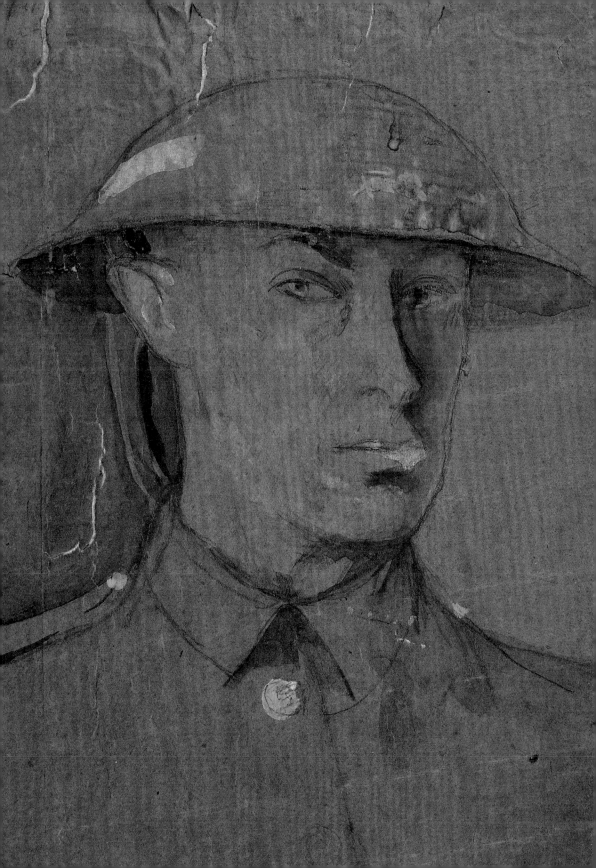

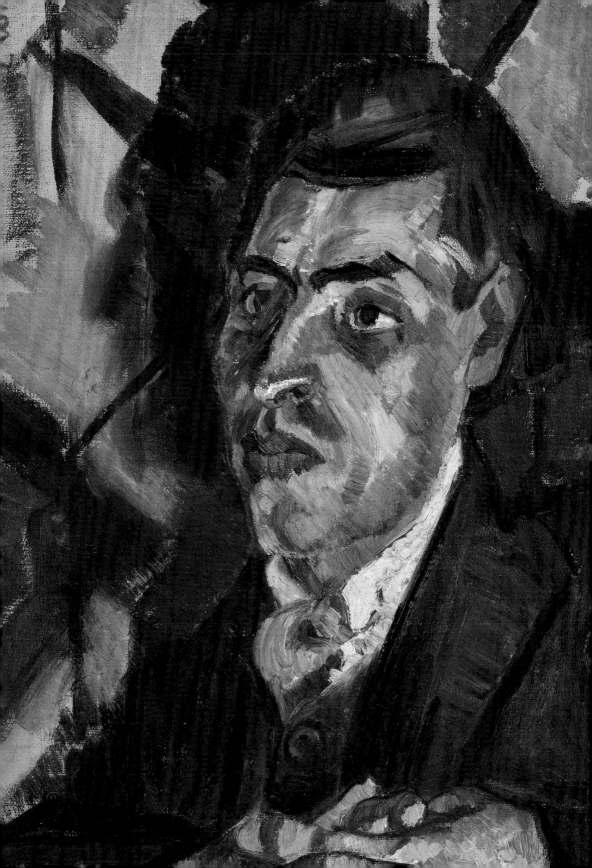

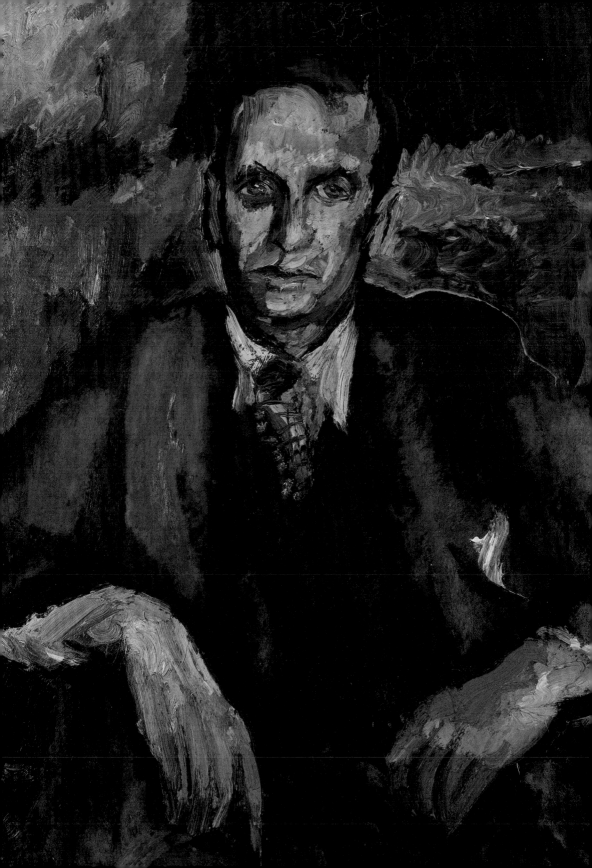

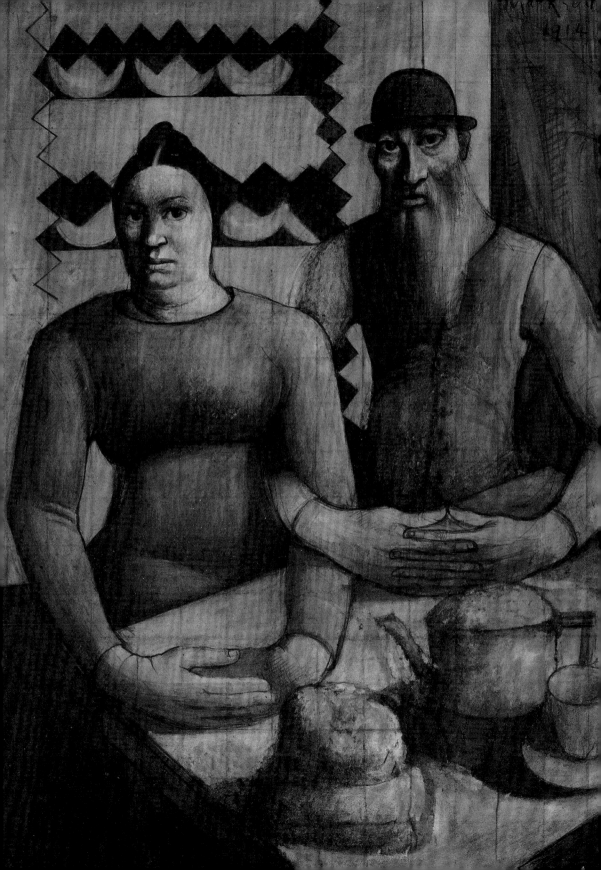

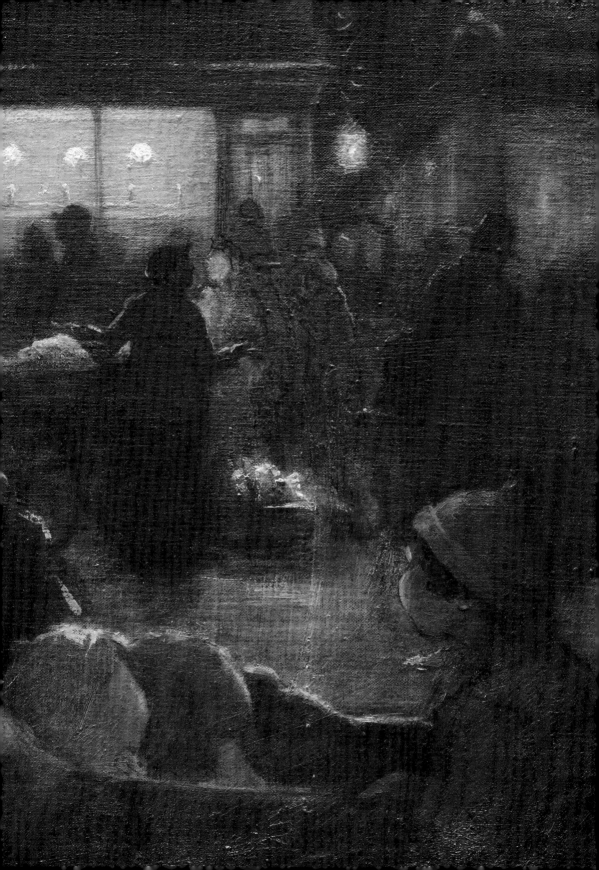

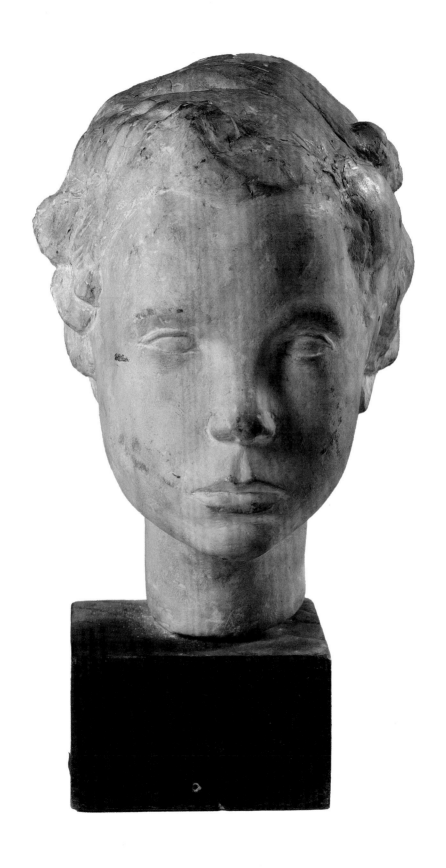

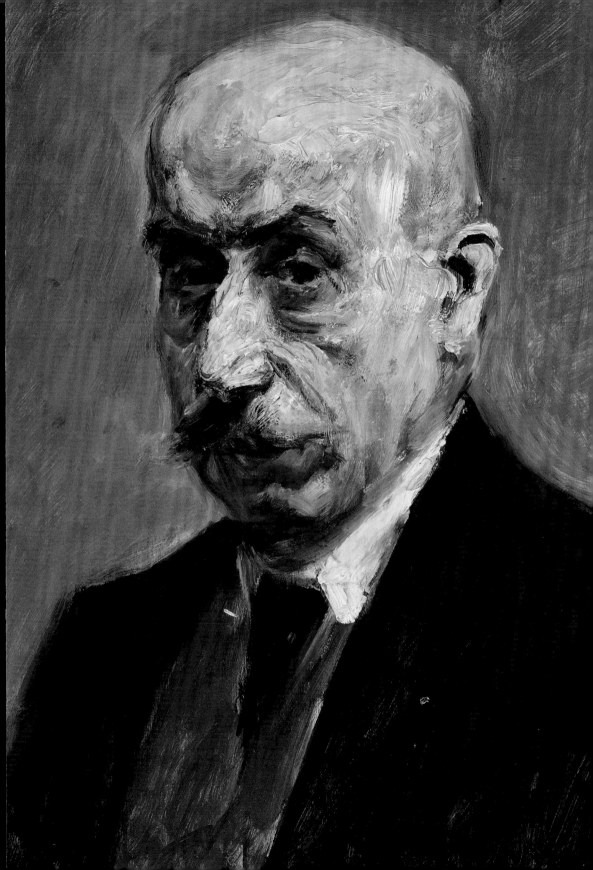

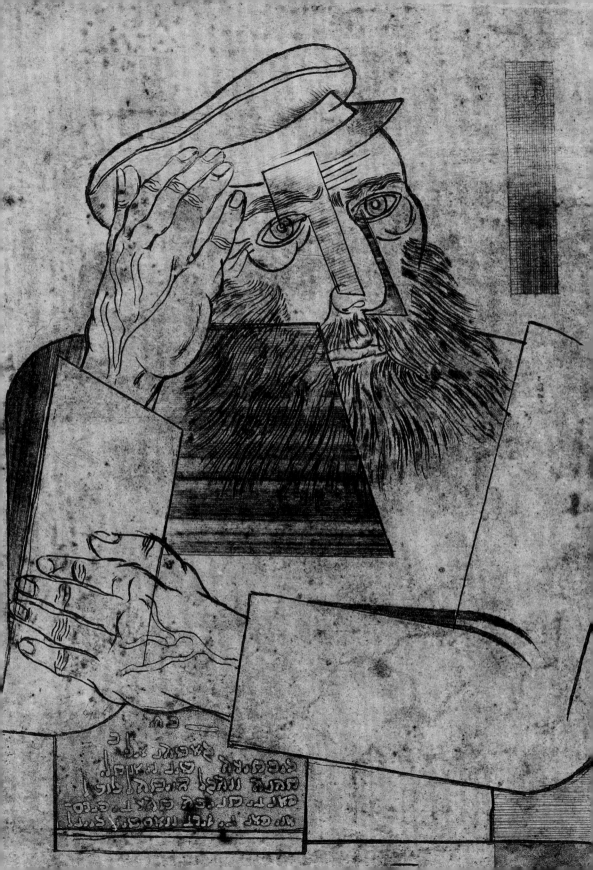

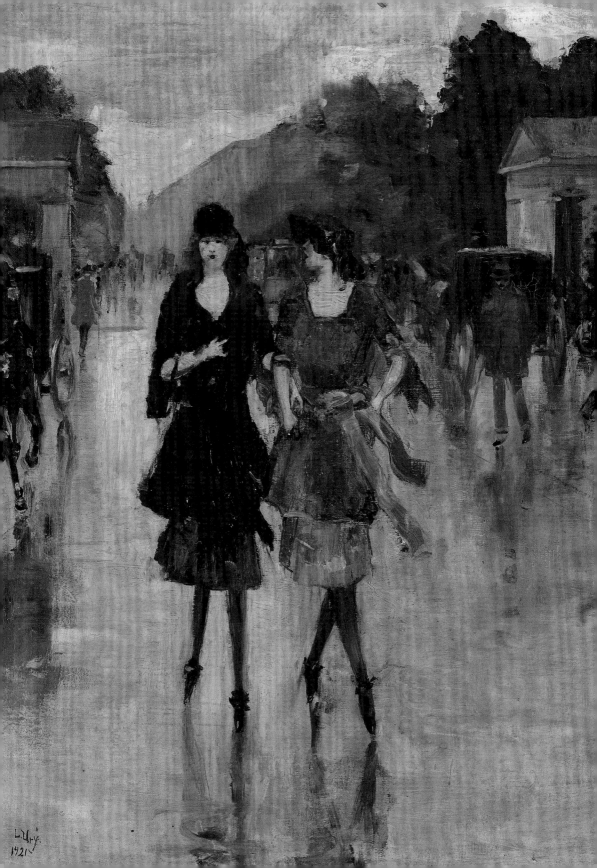

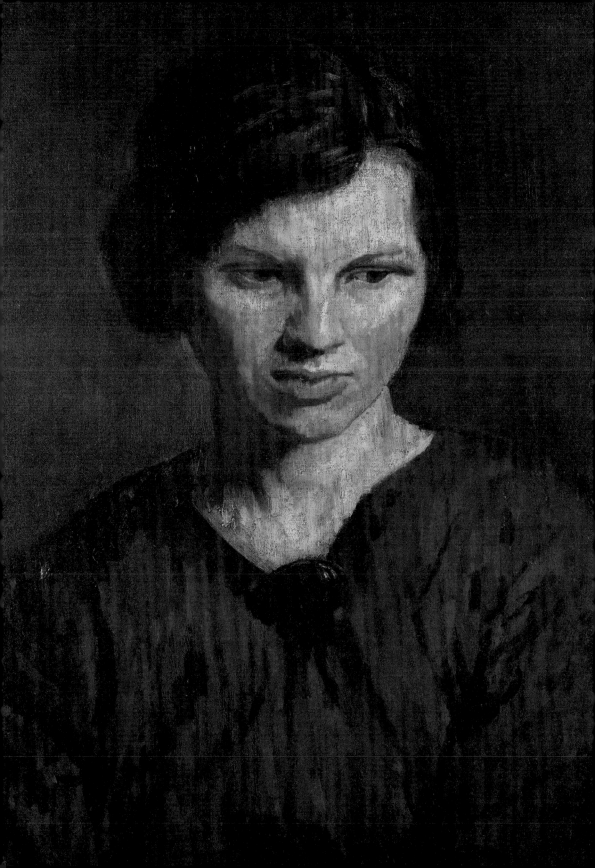

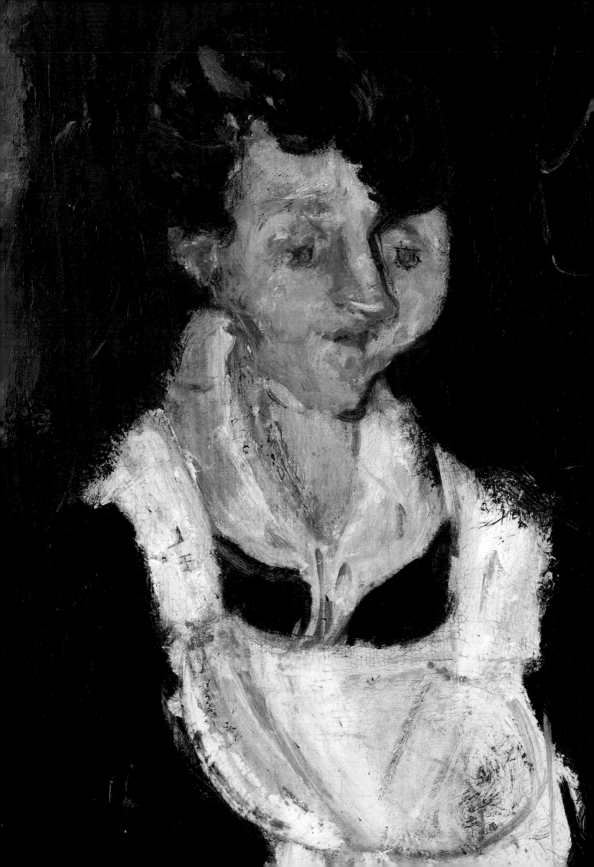

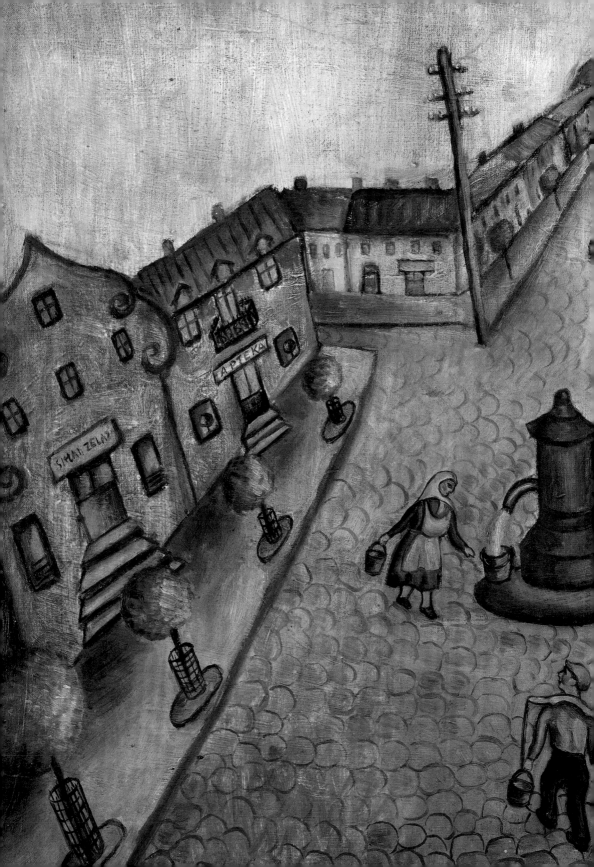

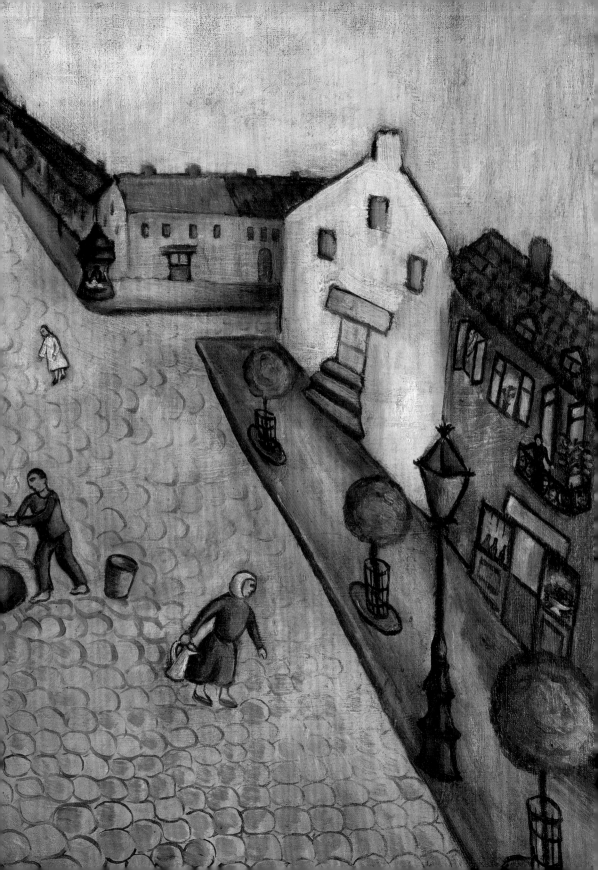

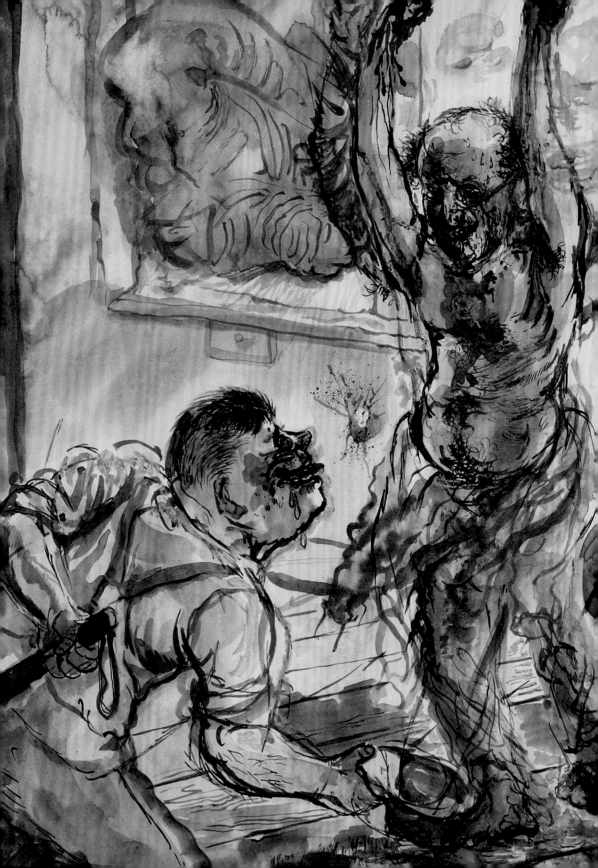

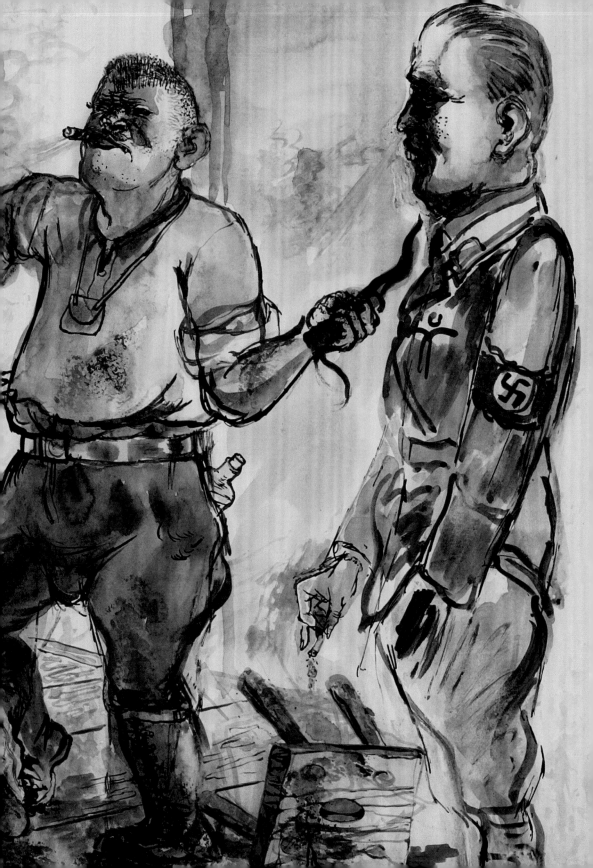

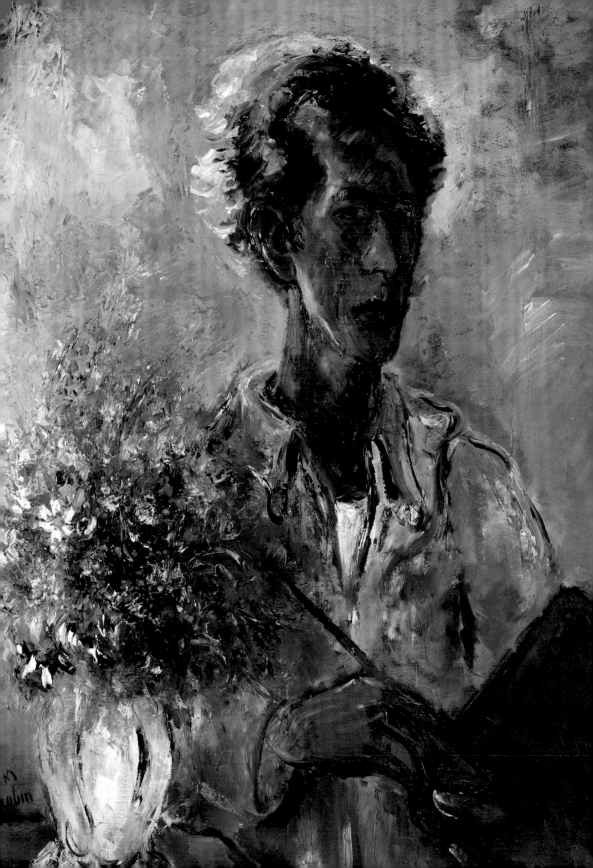

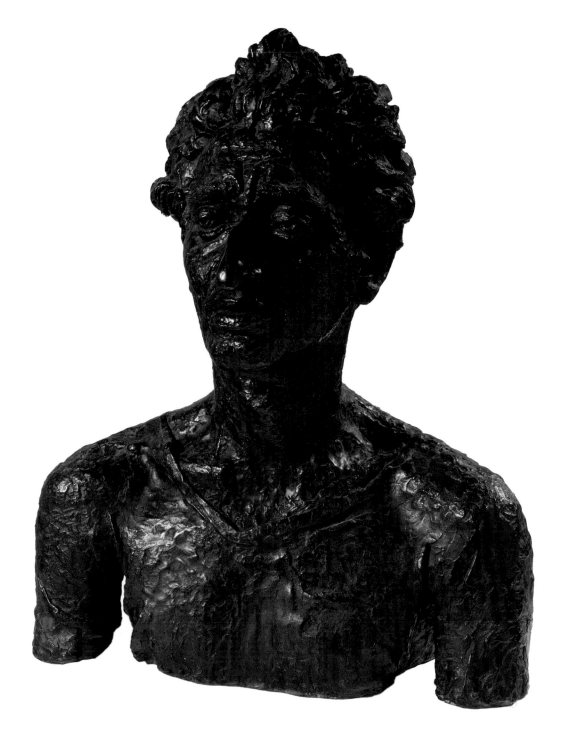

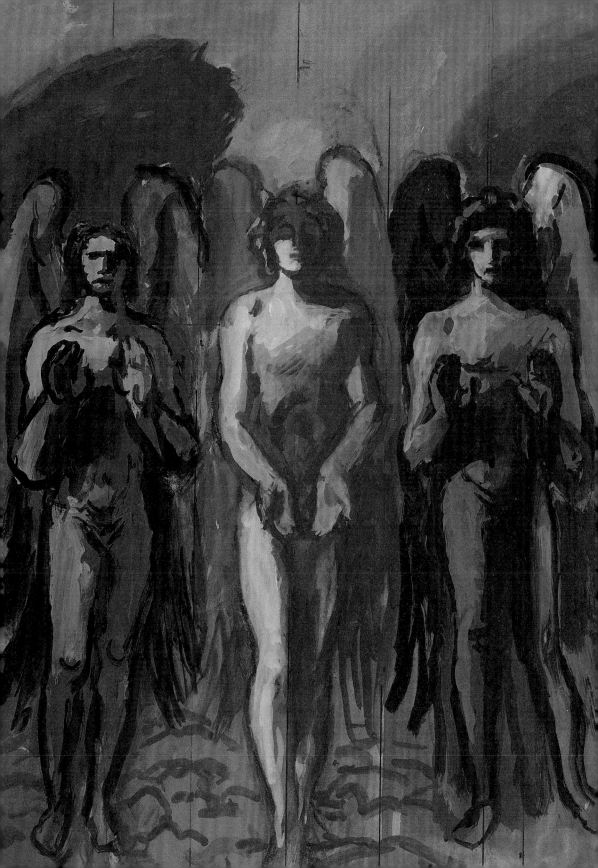

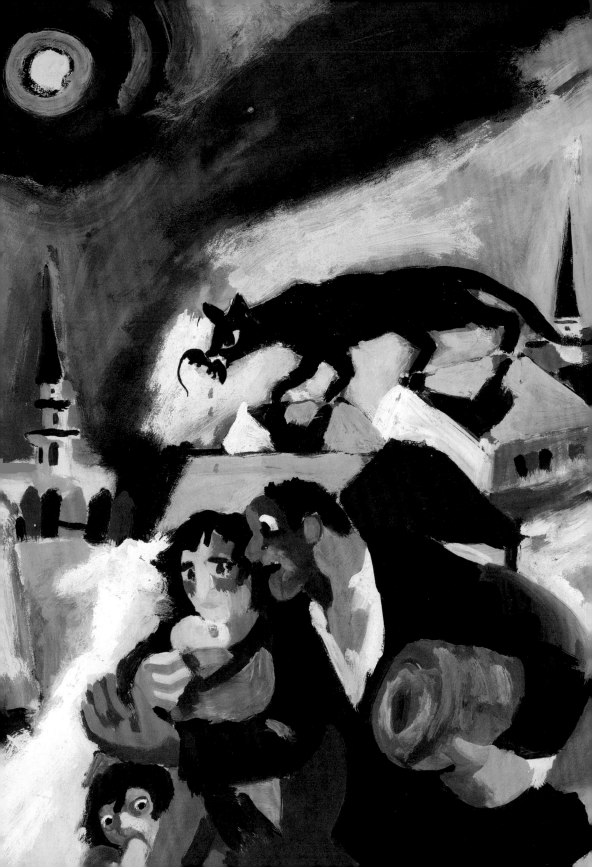

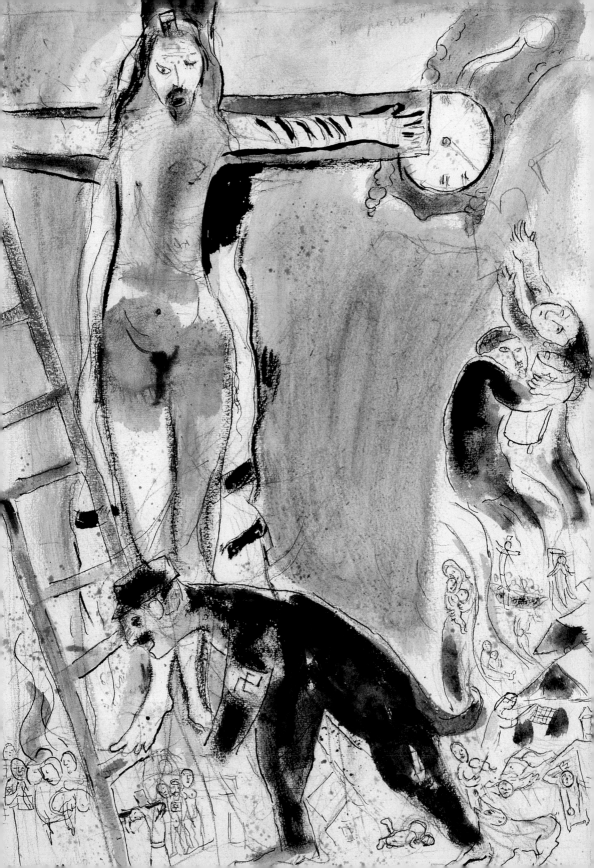

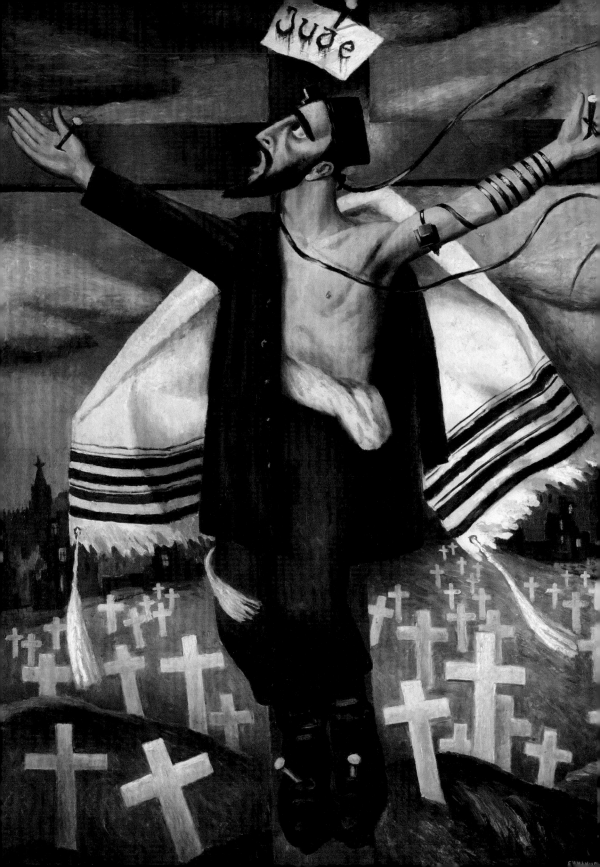

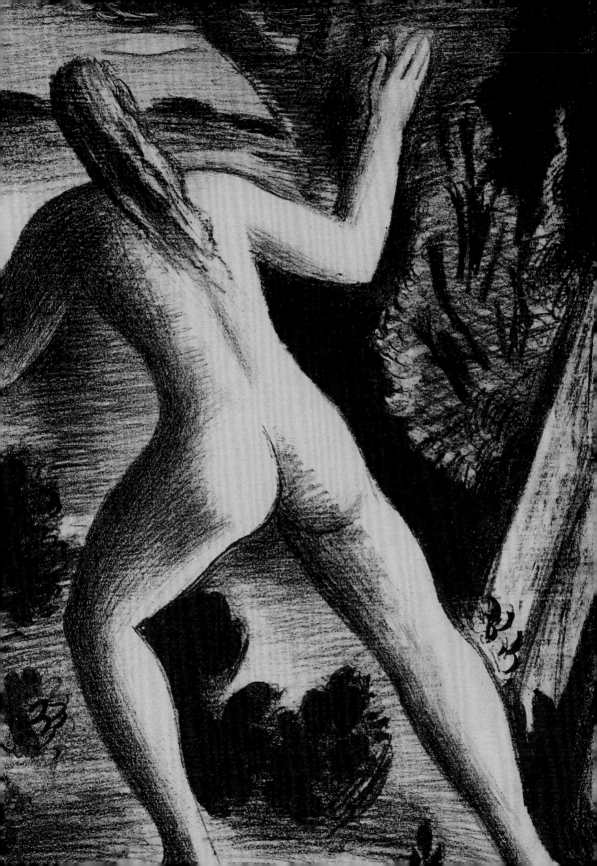

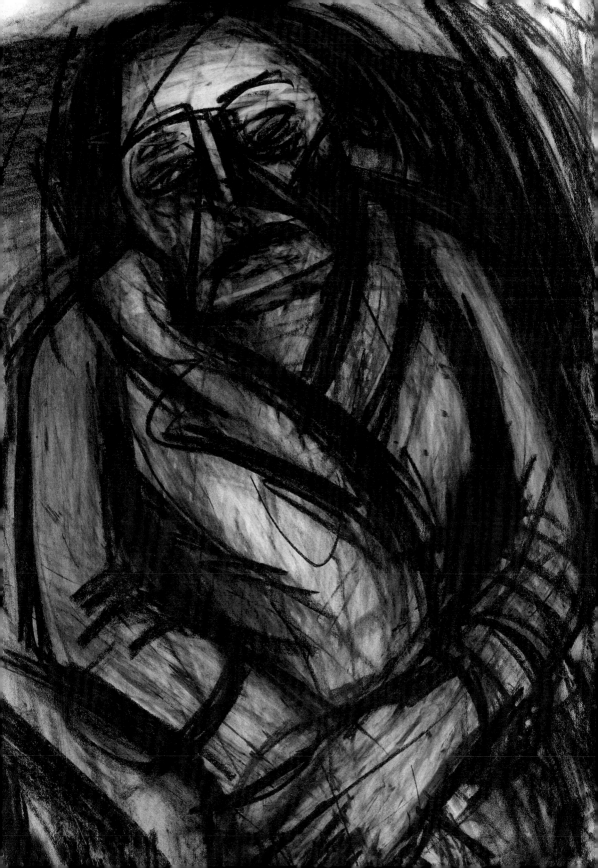

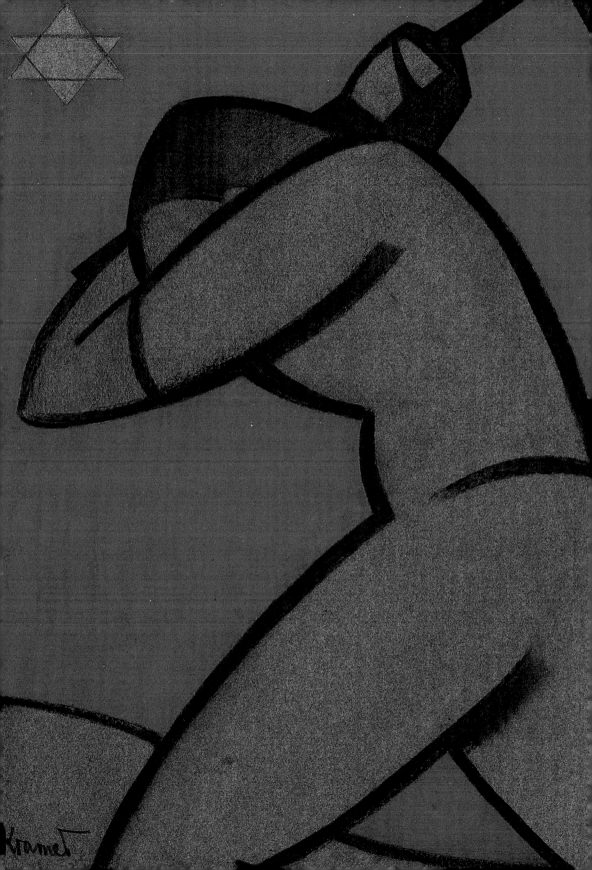

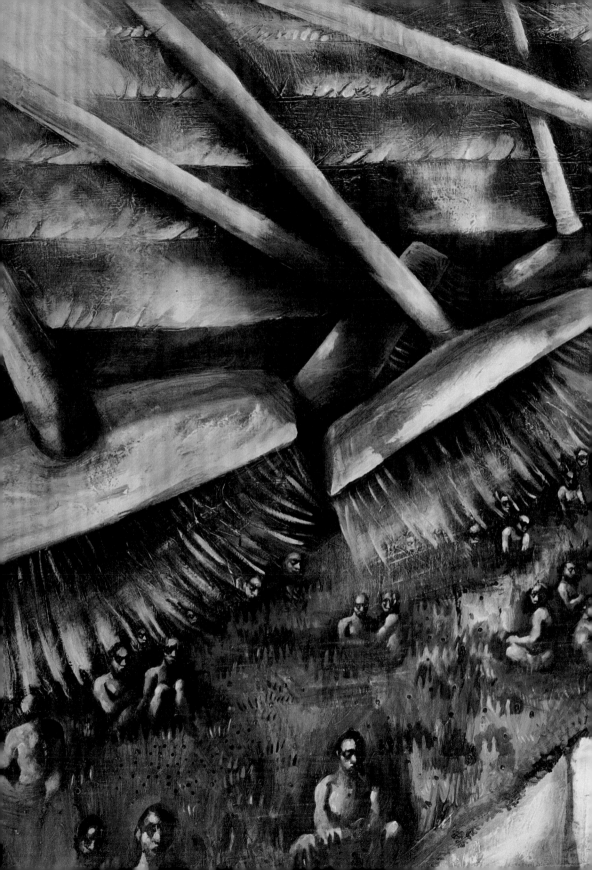

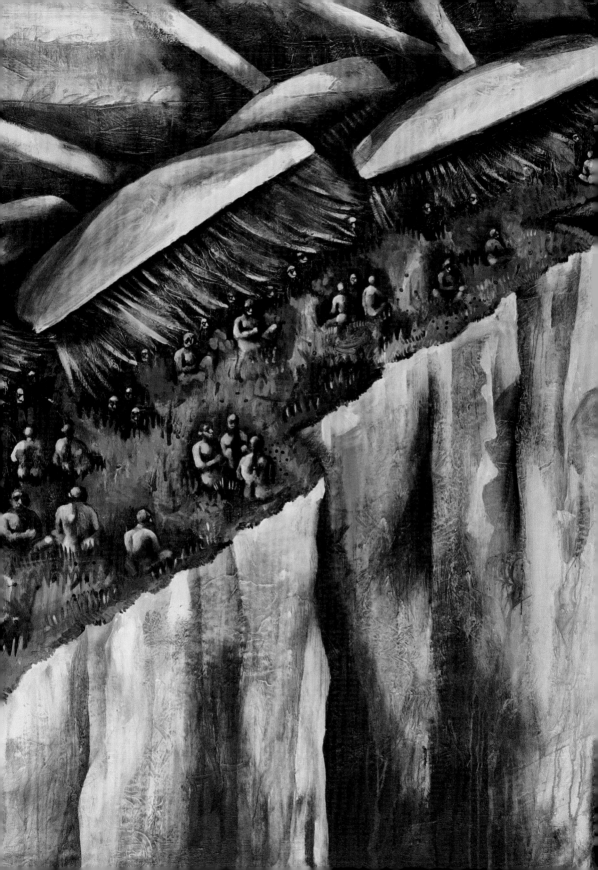

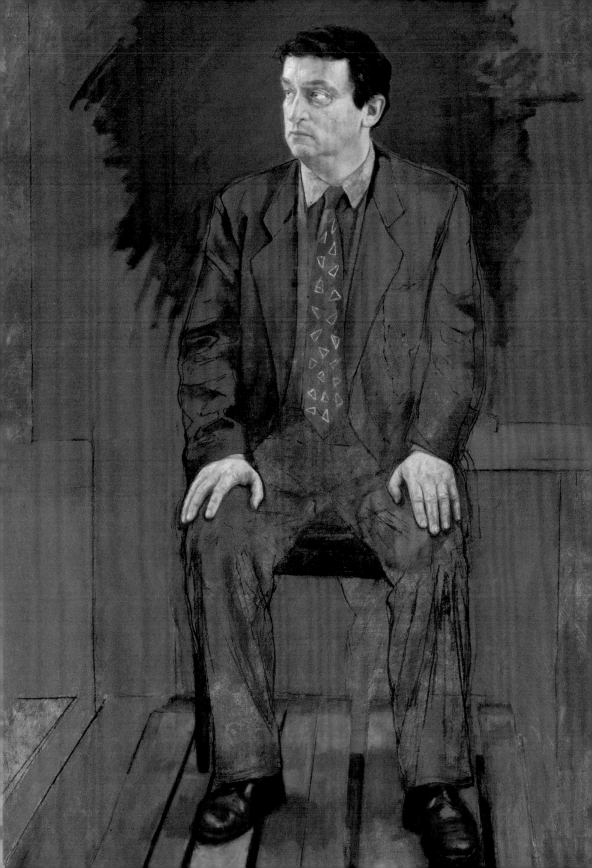

The student from
Cleveland, Ohio.
Pratt Institute of
Art, Brooklyn,
N.Y.C.

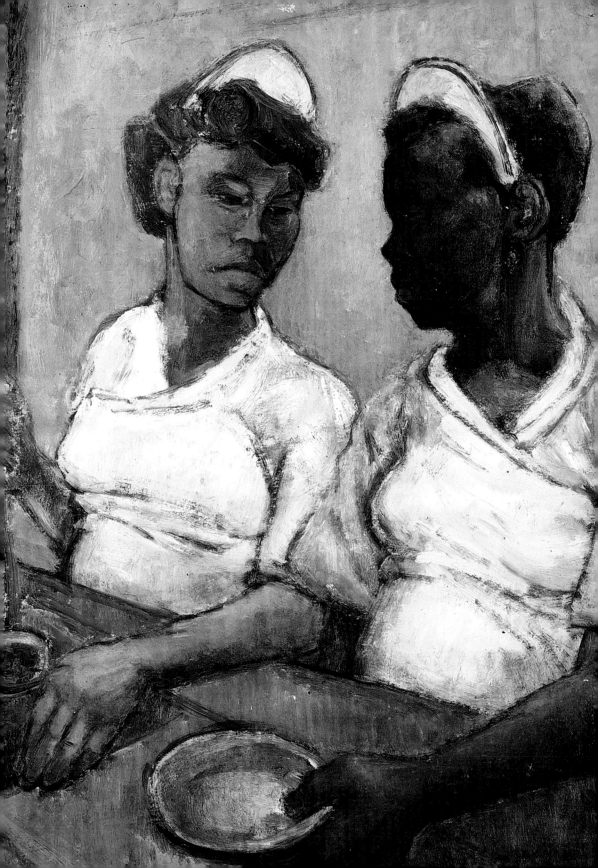

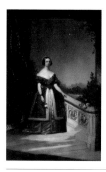

1
Solomon Alexander Hart, RA
Portrait of Queen Victoria,
1842
Oil on canvas, 119.5 × 77.5 cm.

On long term loan to Ben Uri Collection

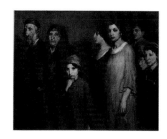

2
Victor Hageman
*The Emigrants, c.*1910
Oil on canvas, 122 × 155 cm.

Presented by the Trafalgar Gallery, London, 2013

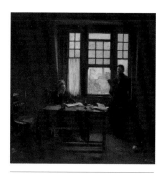

3
Alfred Wolmark
*Sabbath Afternoon, c.*1909–10
Oil on canvas, 77.5 × 77.5 cm.

Acquired in 2013 with the assistance of the HLF,
the V&A Purchase Grant Fund and the Art Fund

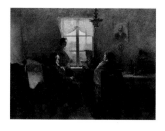

4
Samuel Hirszenberg
Sabbath Rest, 1894
Oil on canvas, 149.5 × 206.5 cm.

Acquired by subscription with the assistance
of Moshe Oved, 1923

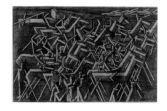

5
David Bomberg
Racehorses, 1913
Black chalk and wash on paper,
41.5 × 66.2 cm

Acquired at Sotheby's in 2004 with assistance of
the Art Fund, the HLF and the MLA/ V&A
Purchase Grant Fund, The Julius Silman
Charitable Trust, Pauline and Daniel Auerbach,
Sir Michael and Lady Morven Heller and
anonymous donors

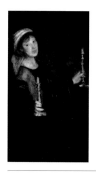

6
Lily Delissa Joseph
Self-portrait with Candles,
*c.*1906
Oil on canvas, 105.5 × 59.5 cm.

Presented by Mrs. Redcliffe Salaman 1948

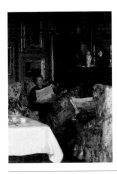

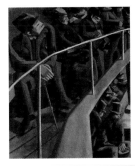

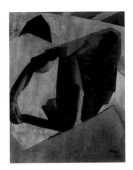

7

Solomon J. Solomon, RA
The Breakfast Table, 1921

Oil on canvas, 69 × 50.5 cm.

Presented by Mrs Ronald Rubenstein, 2002

8

David Bomberg
Ghetto Theatre, 1920

Oil on canvas, 74.4 × 62 cm.

Purchased direct from the artist 1920

9

David Bomberg
English Woman, 1920

Oil on canvas on board, 59.5 × 49.5 cm.

Presented by Mr. and Mrs. H. Rose, 1960

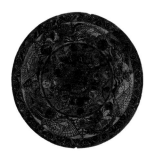

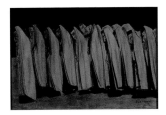

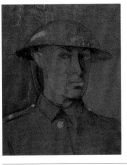

10

Lazar Berson
Circular Design for Ben Uri Art Society, 1915

Pen and coloured inks on paper,
44 cm diameter.

Presented by D. Simkovitz 1915

11

Jacob Kramer
The Day of Atonement, 1919

Pencil, brush and ink on paper,
63.5 × 93 cm.

12

Isaac Rosenberg
Self-portrait in Steel Helmet,
1916

Black chalk, gouache and wash on
paper, 22.4 × 19.6 cm.

Acquired in 2009 with the assistance of the Art
Fund, the MLA/V&A Purchase Grant Fund and
anonymous donors

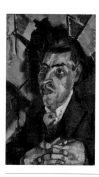

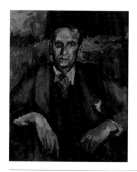

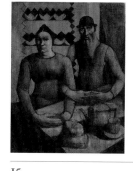

13
Clare Winsten
Portrait of Joseph Leftwich,
*c.*1919–20

Oil on canvas, 40.6 × 25.4 × cm

14
David Bomberg
Portrait of John Rodker,
*c.*1936

Oil on canvas, 71.5 × 57 cm.

Presented by Joan Rodker, 2008

15
Mark Gertler
Rabbi and Rabbitzin, 1914

Watercolour and pencil on paper,
48.8 × 37.6 cm.

Acquired in 2002 by private treaty through
Sotheby's with the assistance of the Art Fund,
HLF, MLA/V&A Purchase Grant Fund, Pauline
and Daniel Auerbach, Sir Michael and Lady
Morven Heller, Agnes and Edward Lee, Hannah
and David Lewis, David Stern, Laura and Barry
Townsley, Della and Fred Worms and anonymous
donors

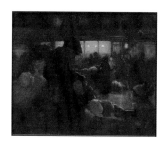

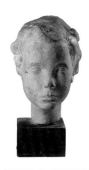

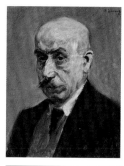

16
Amy J. Drucker
For He Had Great Possessions,
1932

Oil on canvas, 49 × 60 cm.

Presented by Dr. Geoffrey Kohnstamm, 1952

17
Bruno Simon
Head of a Boy, 1946

Plaster, 24 cm (height).

Purchased 1952

18
Max Liebermann
Self-portrait, 1927

Oil on board, 48 × 38 cm.

On long term loan from the Zondek Legacy
through the good offices of the Board of Belsize
Synagogue, 2002

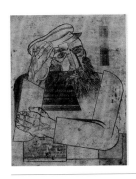

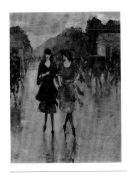

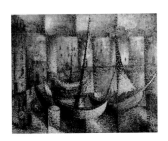

19

Jankel Adler

Ein Jude, *c.*1926

Etching on paper, 44.5 × 34.7 cm.

Purchased from Peter Gidal and his mother 2008

20

Lesser Ury

Berlin Street Scene, 1921

Oil on canvas, 63.2 × 48.1 cm.

Presented by Miss Stephanie Ellen Kohn 1990

21

Arthur Segal

Harbour, La Ciotat, 1929

Oil on canvas, 68.5 × 88.3 cm.

Acquired prior to 1959

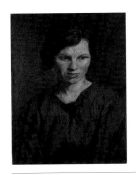

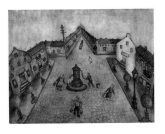

22

Isaac Rosenberg

Portrait of Sonia, 1915

Oil on canvas, 60 × 44 cm.

Presented by Joan Rodker, 2008

23

Chaïm Soutine

La Soubrette (Waiting Maid),
*c.*1933

Oil on canvas, 46.5 × 40.5 cm.

Acquired in 2012 with the assistance of the HLF,
the Art Fund, the V&A Purchase Grant Fund,
Miriam and Richard Borchard, Sir Harry and
Lady Djanogly, Patsy & David Franks, Sir
Michael and Lady Morven Heller, Joan and
Lawrence Kaye (USA), Laura and Lewis Kruger
(USA), Agnes & Edward Lee, Simon Posen
(USA), The Marc Rich Foundation (Switzerland),
Anthony Rosenfelder & family in honour of
Marilyn, Jayne Cohen and Howard Spiegler
(USA), and Judit & George Weisz

24

Chana Kowalska

Shtetl, 1934

Oil on canvas, 45 × 60 cm.

Presented by Mrs. Moshe Oved 1962

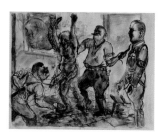

25

George Grosz

Interrogation, 1938

Watercolour and ink on paper,
46 × 59 cm.

Acquired in 2010 with the assistance of the Art
Fund, the MLA/V&A Purchase Grant Fund, Sir
Michael and Lady Morven Heller, Judit and
George Weisz, Agnes and Edward Lee, and The
Montgomery Gallery, San Francisco

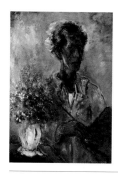

26

Reuven Rubin

Self-portrait, 1937

Oil on canvas, 91 × 63.5 cm.

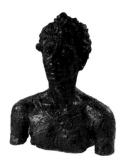

27

Jacob Epstein

Bust of Jacob Kramer, 1921

Bronze, 64 × 49 × 25 cm.

Acquired at Bonhams in 2003 with the assistance
of the Art Fund, V&A Purchase Grant Fund,
Pauline and Daniel Auerbach, Sir Michael and
Lady Morven Heller and anonymous donors

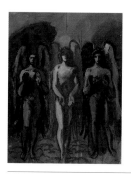

28

Hans Feibusch

Three Messengers, 1988

Gouache on paper, 35 × 21 cm.

Presented by the artist, 1994

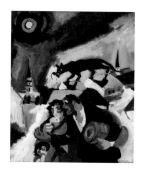

29

Josef Herman

*Refugees, c.*1941

Gouache on paper, 47 × 39.5 cm.

Purchased with the kind assistance of the
ACE/V&A Purchase Grant Fund and the Art
Fund 2014 via Conor Macklin of the Grosvenor
Gallery

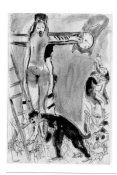

30

Marc Chagall

Apocalypse en Lilas, Capriccio,
1945

Gouache, pencil, indian wash ink and
indian ink on paper, 51.2 × 36.3 cm.

Acquired in 2010 with the help of Miriam and
Richard Borchard, Sir Michael and Lady Morven
Heller and benefitting from the advice of Lionel
Pissarro of GPS Partners and The Art Fund

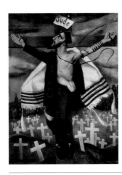

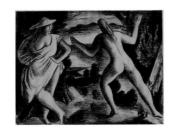

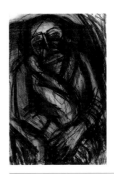

31

Emmanuel Levy

Crucifixion, 1942

Oil on canvas, 102 × 78 cm.

Purchased 2004

32

Bernard Meninsky

Bathers in a Landscape

Lithograph on paper, 65 × 51 cm.

Presented by the Contemporary Art Society in
memory of Cecil Lowenthal, 2002

33

Leon Kossoff

Portrait of N. M. Seedo,
*c.*1957

Charcoal on paper, 103 × 71 cm.

Purchased 1987

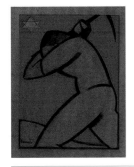

34

Jacob Kramer

Design for a programme
*(Pioneers), c.*1920

Charcoal, gouache and pencil on paper,
38 × 30 cm.

Presented by Mrs E. Hurwitz

35

David Breuer-Weil

The Edge, 2007

Oil on canvas, 192 × 364.1 cm.

Presented by the artist 2007

36

Joash Woodrow

White Trees and Yellow Fence,
1980

Oil and household paint on board,
217.5 × 165 cm.

Presented by the Joash Woodrow collection and
108 Fine Art

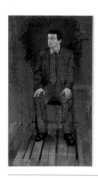

37

Daniel Quintero

Sir Norman Rosenthal, 1996

Oil on canvas, 157.5 × 91.5 cm.

Presented by the artist 2013

38

Bernard Cohen

Untitled II, 1974

Gouache on paper, 39.5 × 77.5 cm.

Presented by Professor Bernard Cohen, 1995

39

Lucien Pissarro

The Pagoda, Kew, 1919

Oil on canvas, 52.5 × 42.5 cm.

Presented by Ethel Solomon

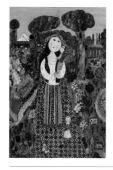

40

Dora Holzhandler

Mother and Children in Holland Park, 1997

Oil on canvas, 121.5 × 82 cm.

Presented by Joan Hurst through the good offices of the Art Fund

41

Michael Rothenstein, RA

The Shooting of George Wallace, 1973

Photographic silkscreen on paper, 55.7 × 76.2 cm.

Presented by Michael Rothenstein, RA

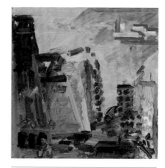

42

Frank Auerbach

Mornington Crescent, Summer Morning II, 2004

Oil on board, 51 × 51 cm.

Acquired in 2006 from Marlborough Fine Art with the assistance of the artist, Marlborough Fine Art, the Art Fund, the V&A / MLA Purchase Grant Fund, Pauline and Daniel Auerbach and anonymous donors

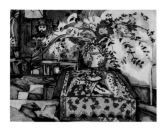

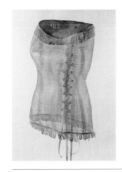

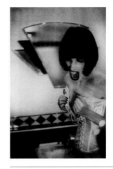

43
Philip Sutton, RA
Claud's still life, 1983

Oil on canvas, 79.4 × 108 cm.

Presented by the Joan Hurst Collection, courtesy
of Robert Travers, Piano Nobile

44
Jacqueline Nicholls
Maternal Torah, 2008

Sinamay (lightweight millinery fabric),
60 × 40 × 22 cm.

Presented by the artist 2008

45
Sophie Robertson
Rage, 2008

Digital photograph, 69 × 45 cm.

Presented by the artist

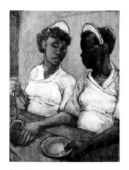

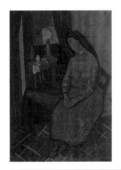

46
Eva Frankfurther
West Indian Waitresses, c.1955

Oil on paper, 76 × 55 cm.

Presented by the artist's sister, Beate Planskoy, 2015

47
Zygmund Landau
Interior

Gouache on paper, 65 × 49 cm.

Presented by Alexander Margulies, 1987

Picture Credits

Copyright